SCORCHED ART

THE INCENDIARY AESTHETIC OF FLAME RITE ZIPPOS

EDITED BY TOM HAZELMYER

This book is dedicated to all the Artists that have been involved with Flame Rite to date, especially those who went the extra mile to make this book happen. Also to Zippo for creating such a great canvas, and the crafts-manship shown by their entire organization.

ISBN: 0-922915-83-0

Printed in China

Feral House
P.O. Box 13067
Los Angeles CA 90013

www.feralhouse.com
info@feralhouse.com

10 9 8 7 6 5 4 3 2 1

FERAL HOUSE

SCORCHED ART

TABLE OF CONTENTS

Photography - CSA Images
Cover design - Charles S. Anderson Design Co.
Writing/editing - Lisa Pemrick
Layout/design - Haze XXL
Assist - Wes Winship & Rainer Fronz

OOP - designates a lighter "Out Of Print"

"Zippo" is a registered trademark of Zippo Manufacturing. The artwork and contents of this book are not endorsed by Zippo Manufacturing, nor does it represent their views or opinions in any way.

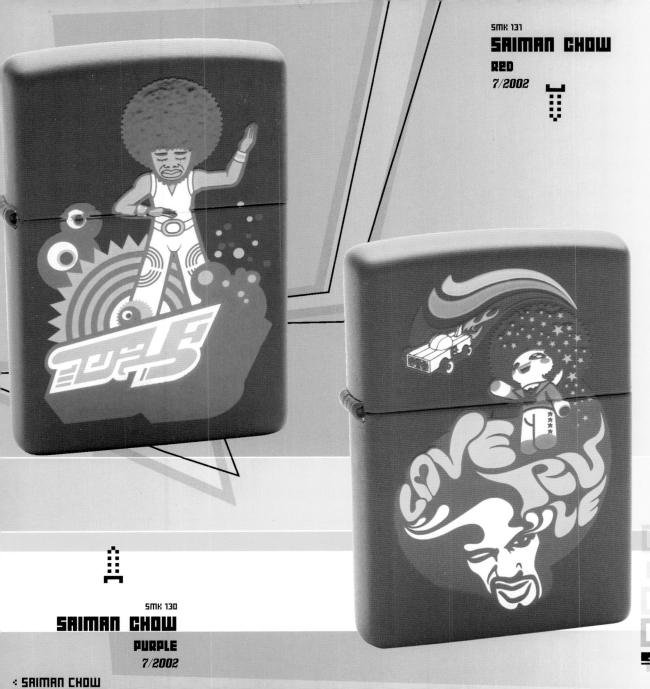

⁒ SAIMAN CHOW

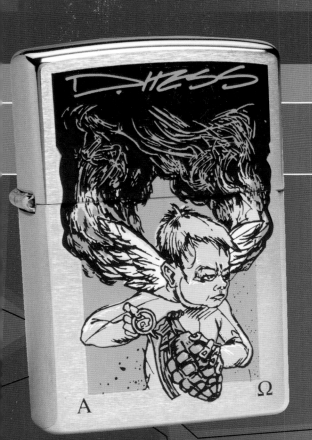

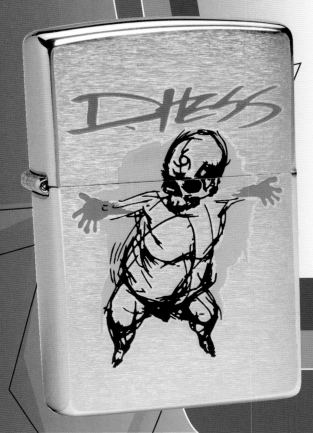

DEREK HESS

OMEGA

6/1997 - OOP

SMK 43

ERECK HESS

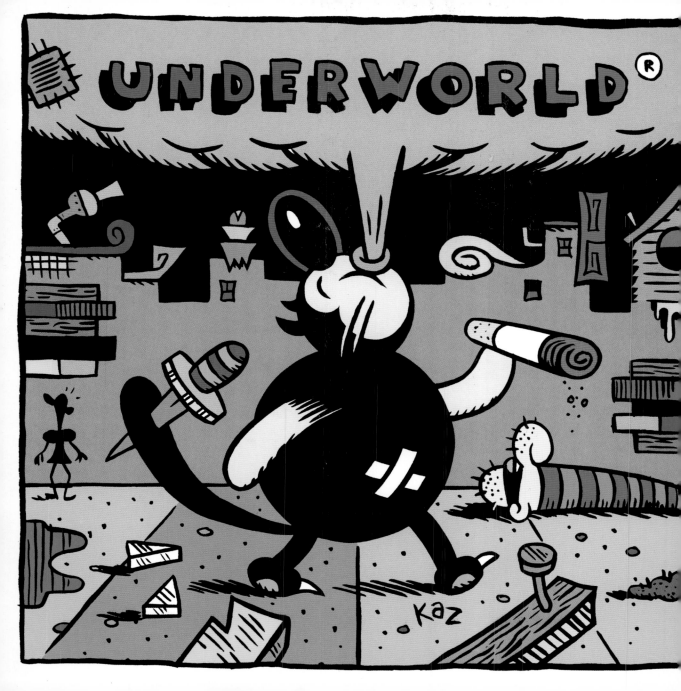

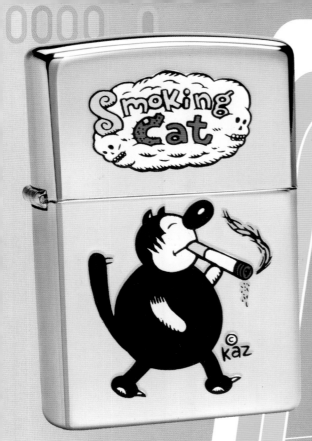

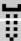

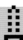

SMK 22
KAZ
SMOKING CAT
11/1995

TM © 1996 SPUMCO INC.

TM © 1996 SPUMCO INC.

SMK 28

SPUMCO-KRICFALUSI
JIMMY WITH KNIFE
7/1996 - OOP

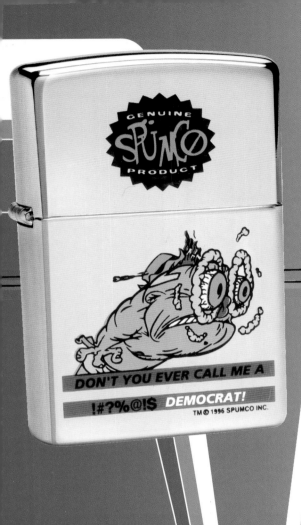

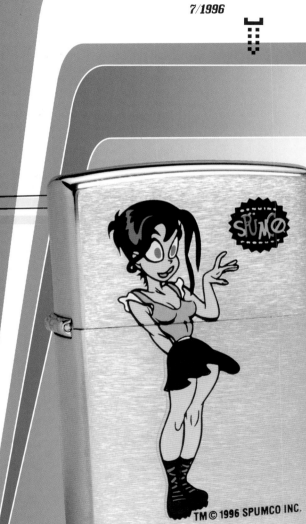

SPUMCO-KRICFALUSI
SODY POP
7/1996

SMK 30

SPUMCO-KRICFALUSI
GEORGE LIQUOR
7/1996 - OOP

11

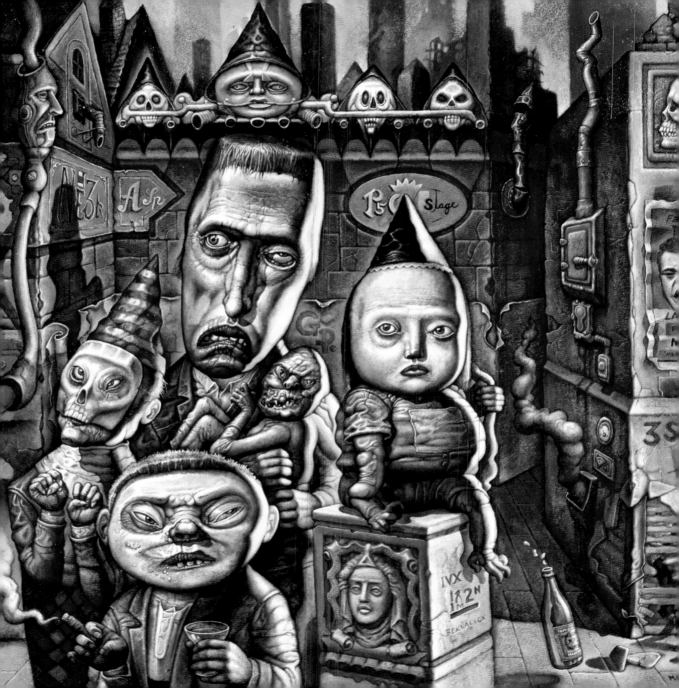

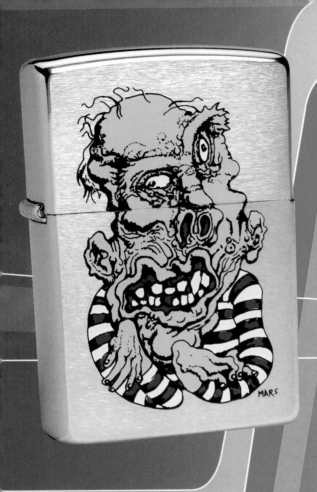

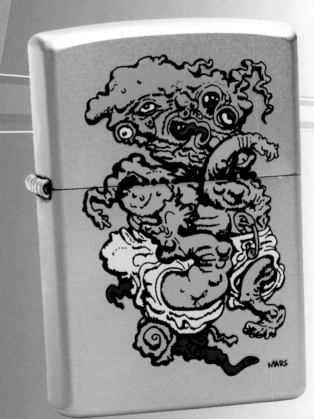

SMK 56
CHRIS MARS
UNCLE COUSIN
7/1997 - OOP

CHRIS MARS THE EXPLOITER OIL ON PANEL

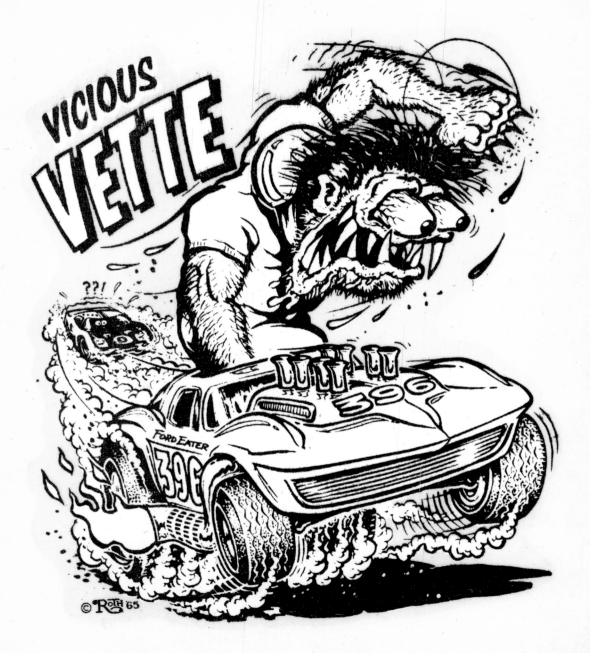

SMK 07

D BIG DADDY ROTH

PURPLE FINK

1/1995

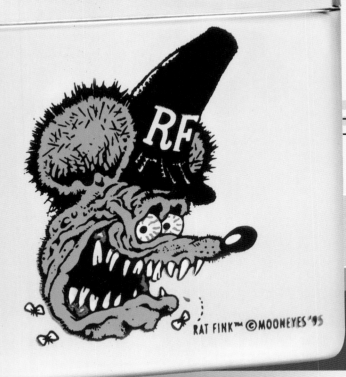

RAT FINK™ ©MOONEYES '95

STUDIOS DECAL CIRCA 1965

15

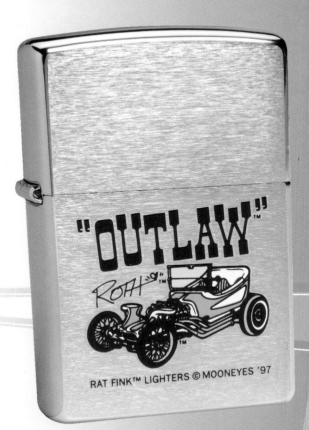

"OUTLAW"™

RAT FINK™ LIGHTERS © MOONEYES '97

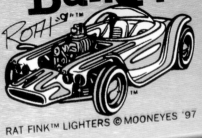

BeaTnik BandiT™

RAT FINK™ LIGHTERS © MOONEYES '97

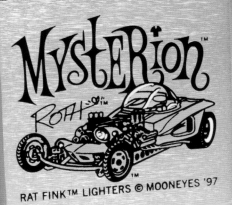

RAT FINK™ LIGHTERS © MOONEYES '97

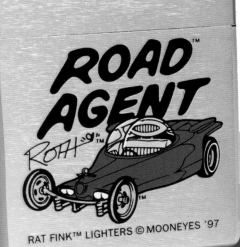

RAT FINK™ LIGHTERS © MOONEYES '97

11

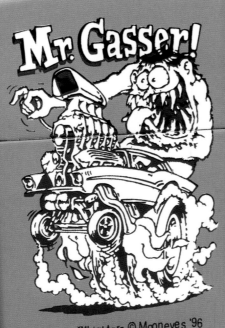

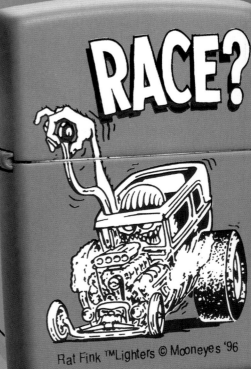

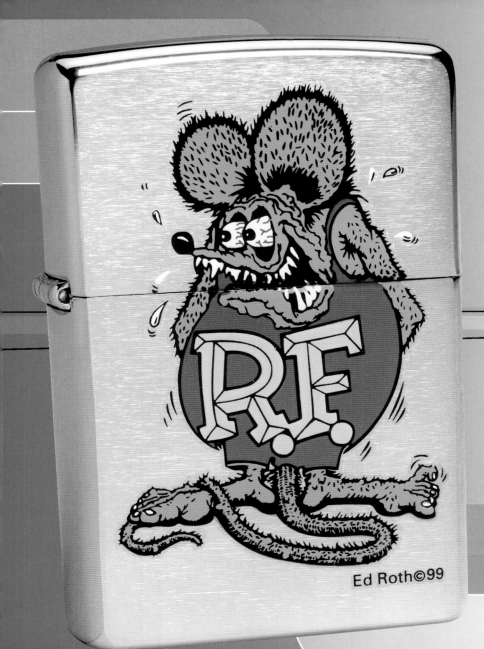

Ed Roth©99

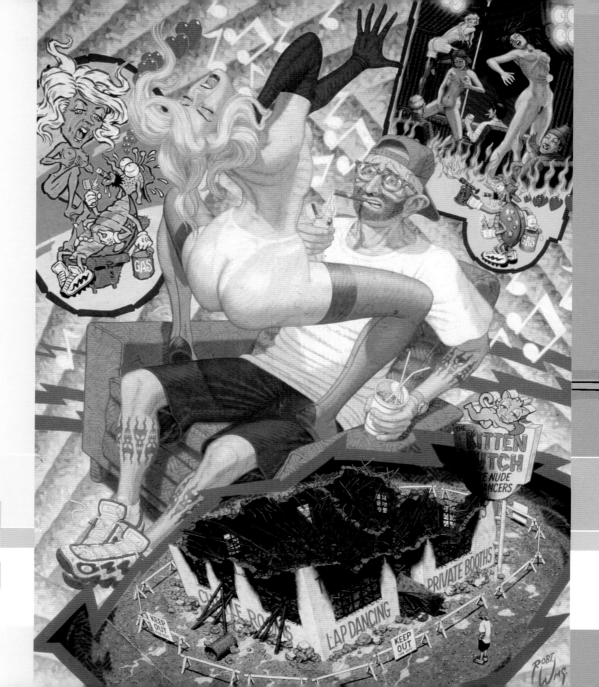

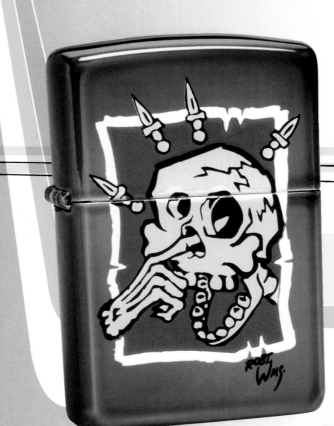

SMK 01

ROBERT WILLIAMS

COOTCHIE COOTY

10/1994 - OOP

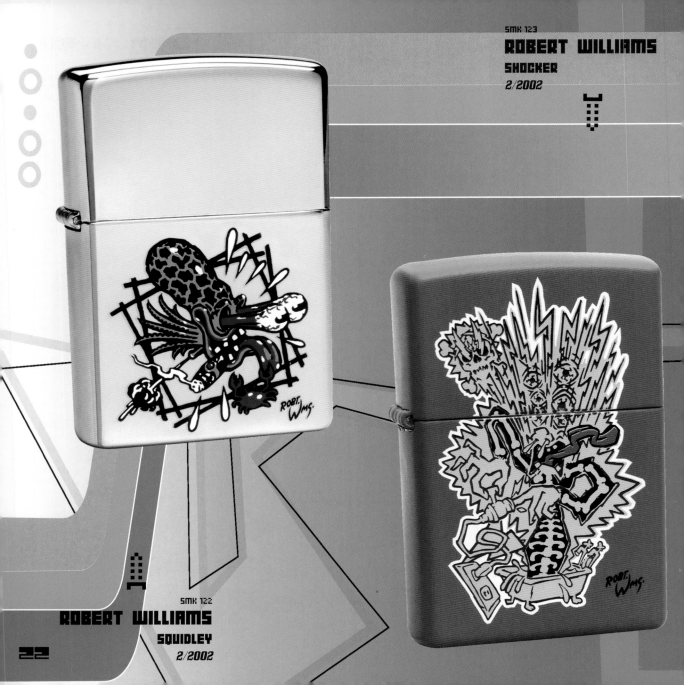

SMK 122
ROBERT WILLIAMS
SQUIDLEY
2/2002

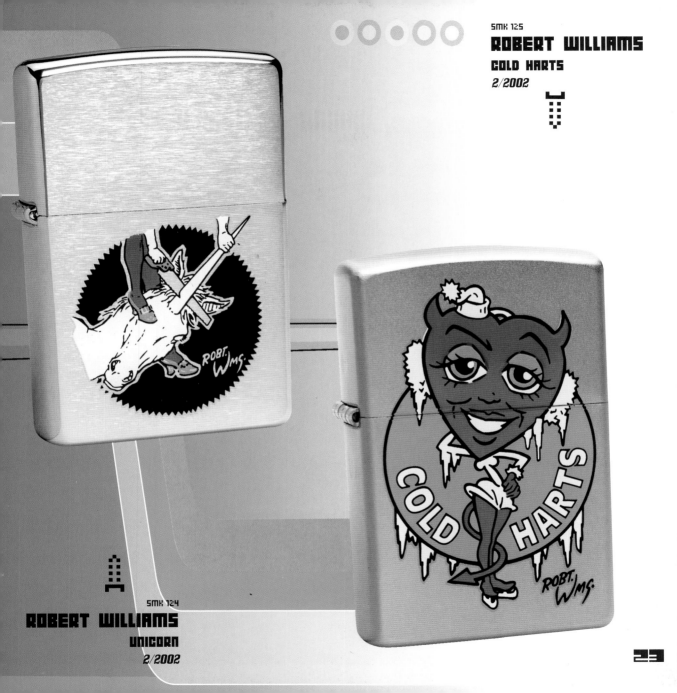

ROBERT WILLIAMS
COLD HARTS
2/2002

ROBERT WILLIAMS
UNICORN
2/2002

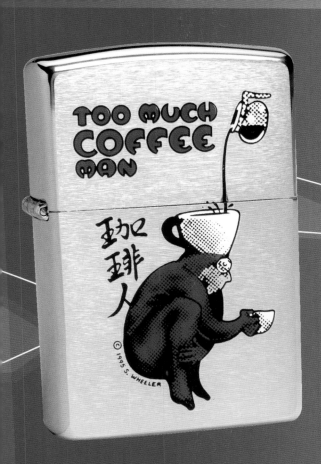

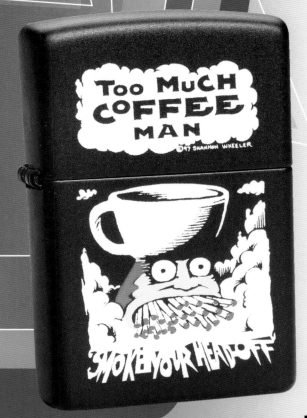

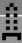

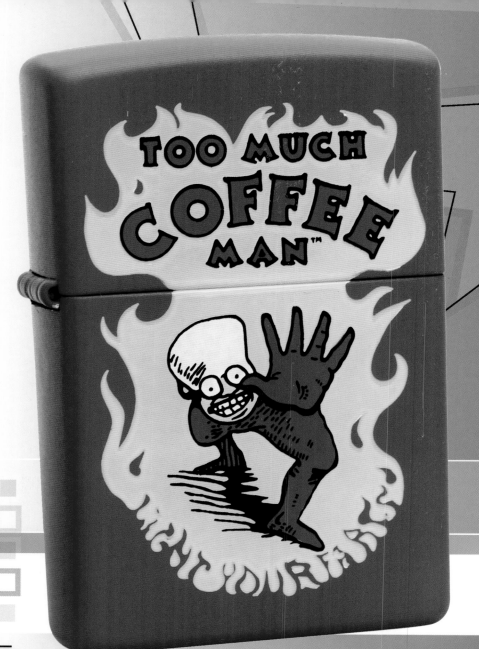

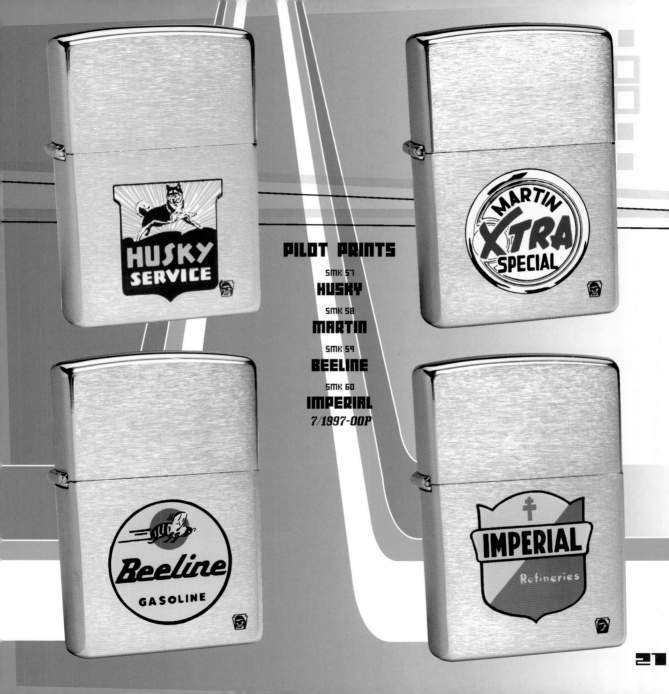

PILOT PRINTS

SMK 57
HUSKY

SMK 58
MARTIN

SMK 59
BEELINE

SMK 60
IMPERIAL

7/1997-OOP

27

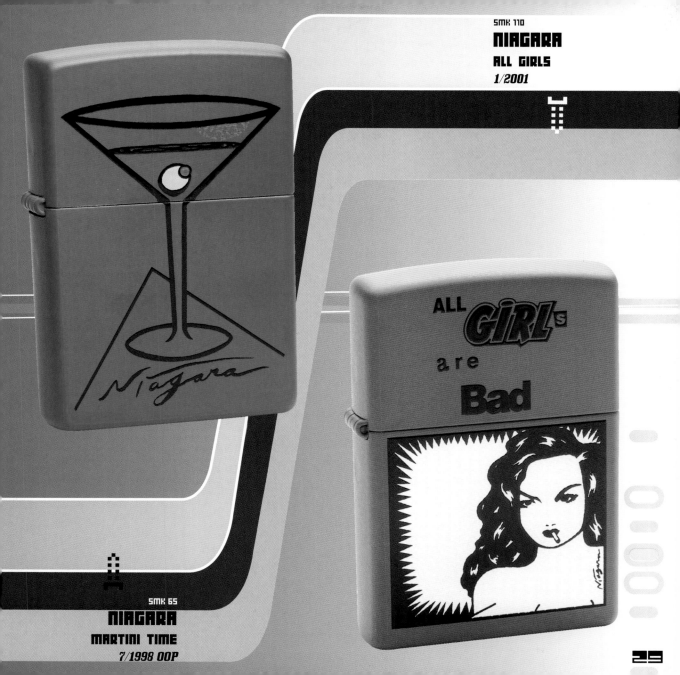

ALL **GIRL**s are **Bad**

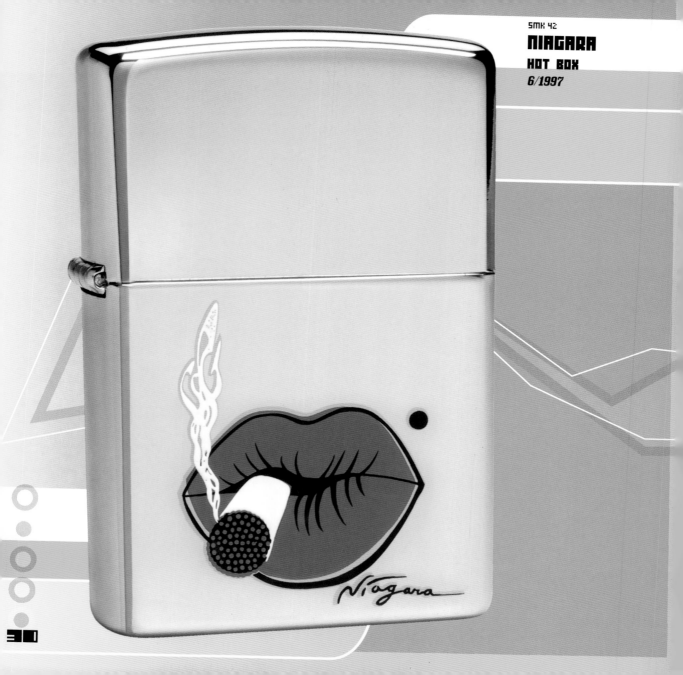

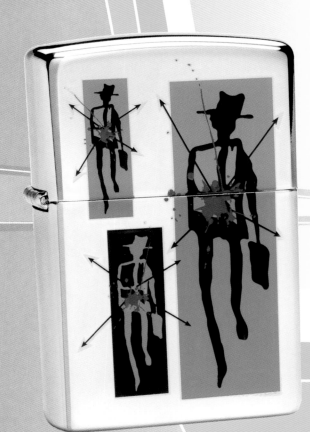

SMK 32

HAZE XXL
FLY OF DEATH
11/1995 - OOP

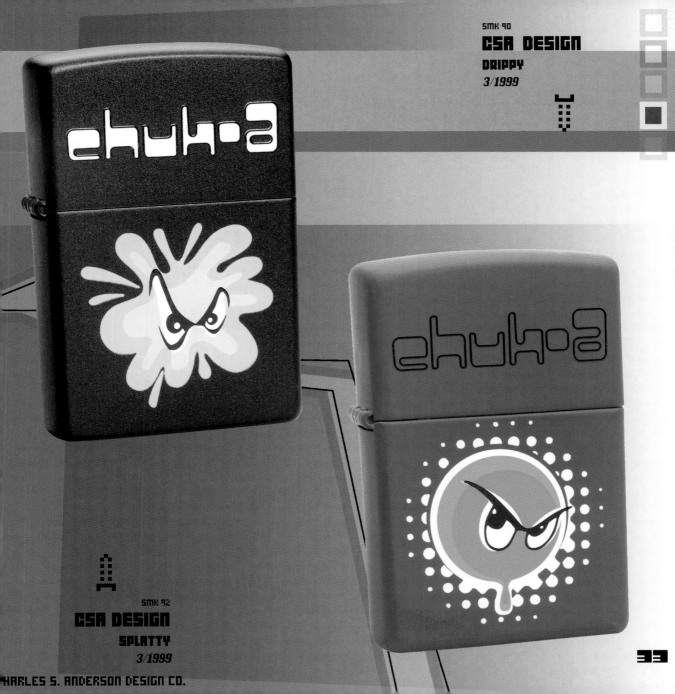

SMK 90
GSA DESIGN
DRIPPY
3/1999

SMK 92
GSA DESIGN
SPLATTY
3/1999

CHARLES S. ANDERSON DESIGN CO.

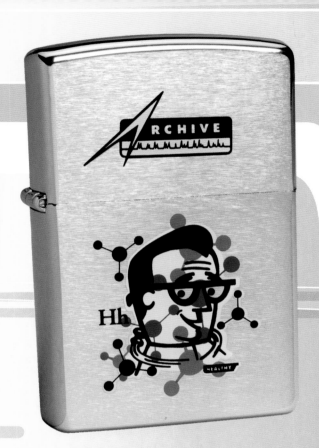

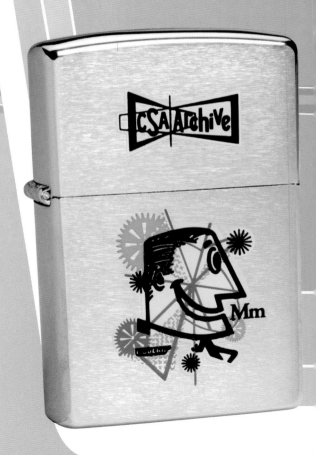

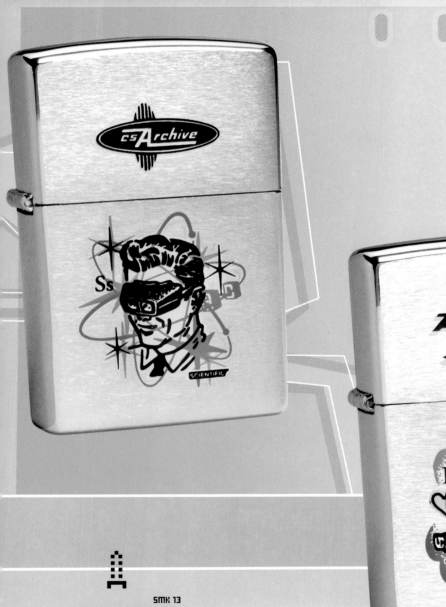

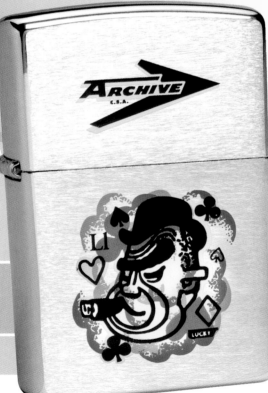

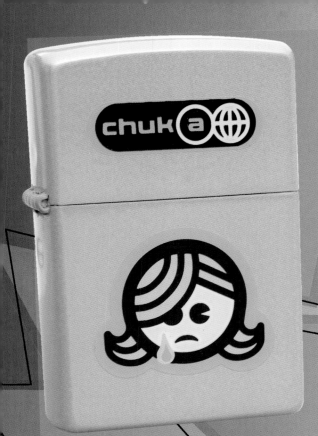

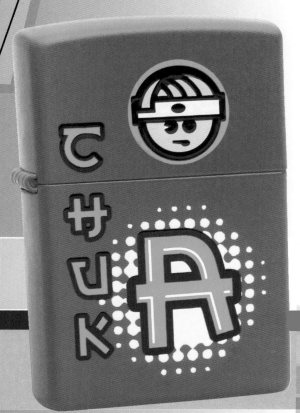

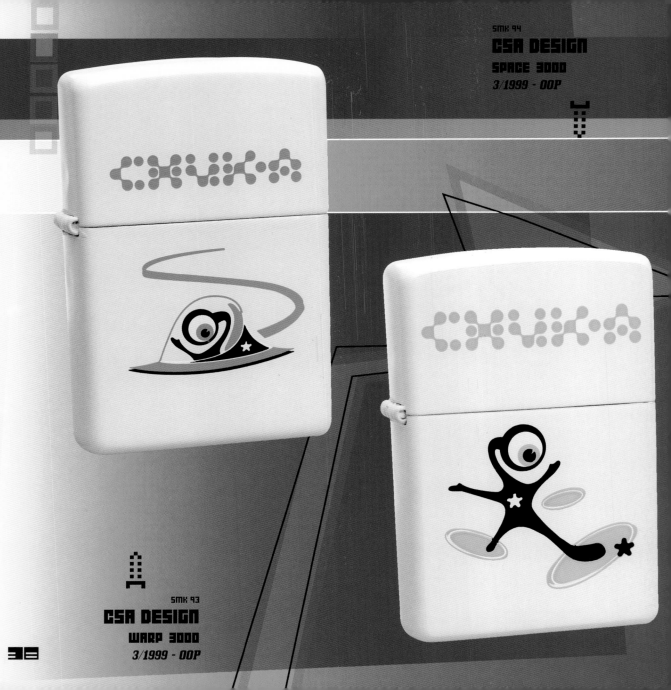

SMK 91

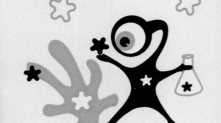

CHUKA

CSA DESIGN
HOTTY
3/1999 - OOP

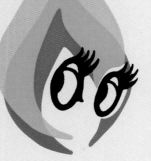

chuka

SMK 95
CSA DESIGN
CHEM 3000
3/1999 - OOP

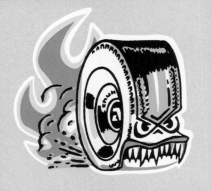

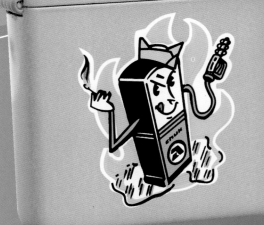

SMK 98
CSA DESIGN
ROAD RASH
7/1999 - OOP

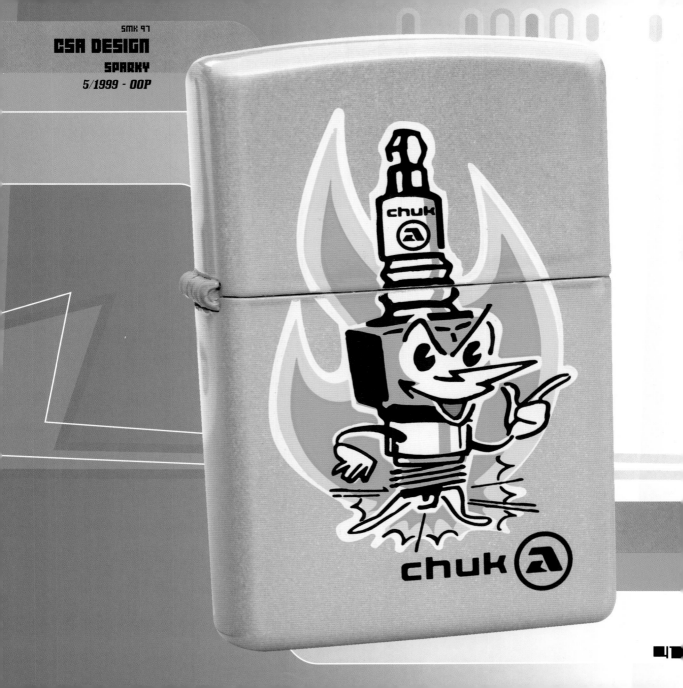

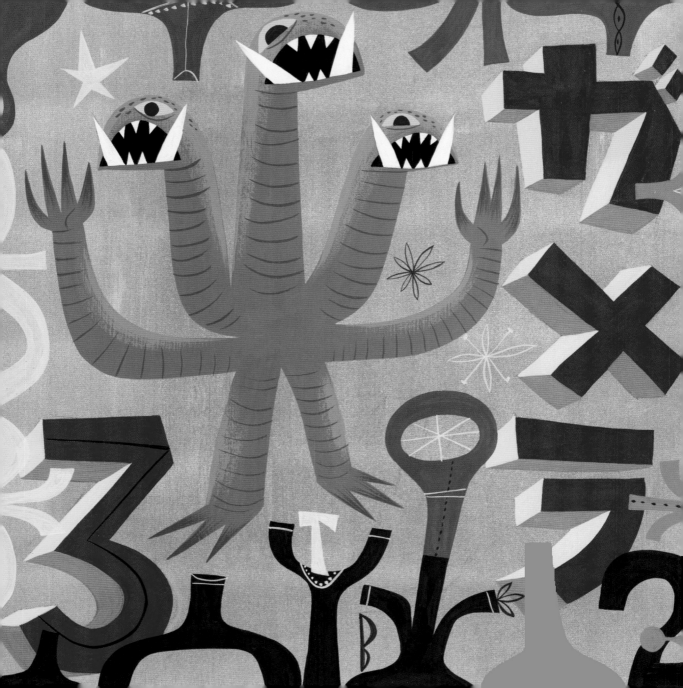

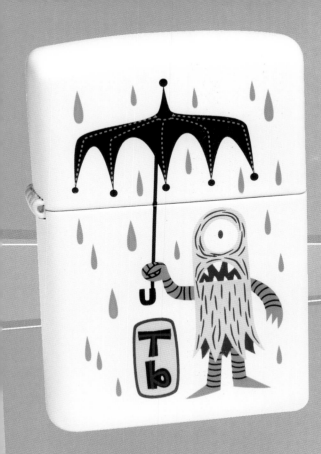

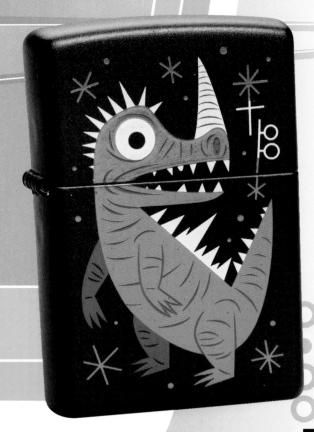

SMK 126
TIM BISKUP
HELPER
6/2002

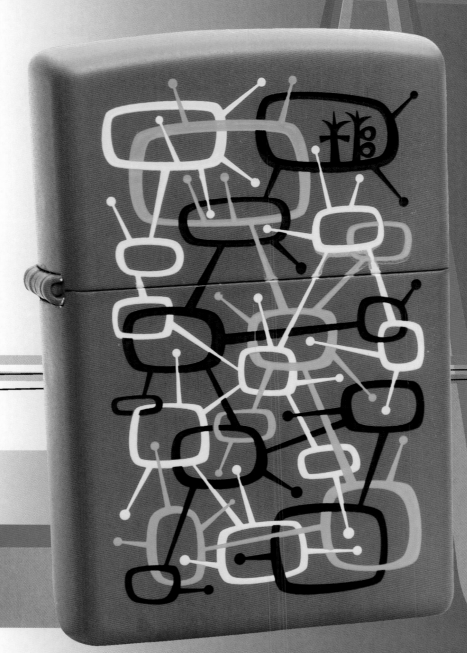

SMK 128
TIM BISKUP
FIREBALL
6/2002

© BURNS

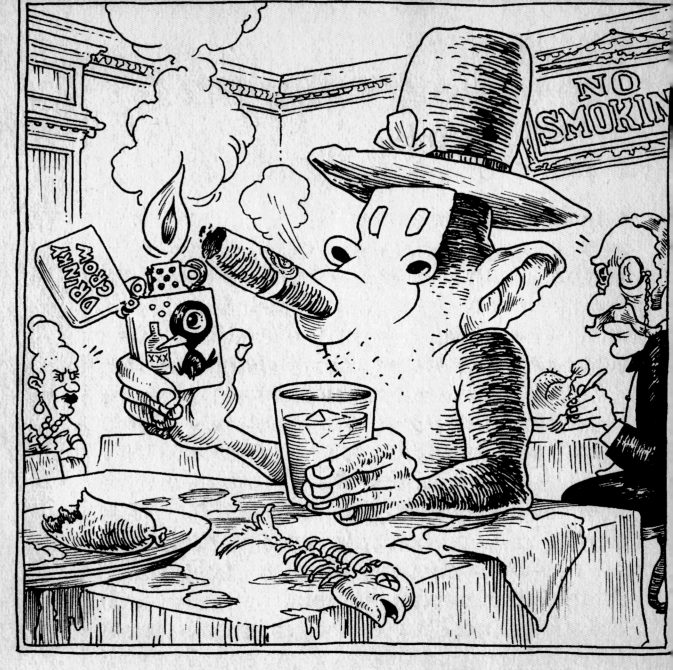

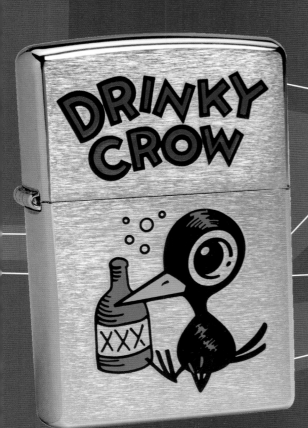

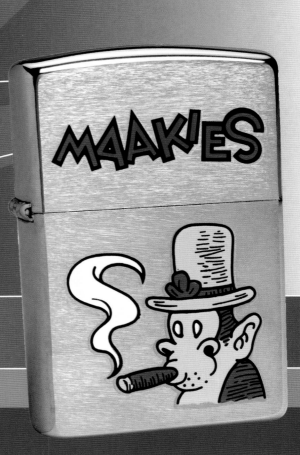

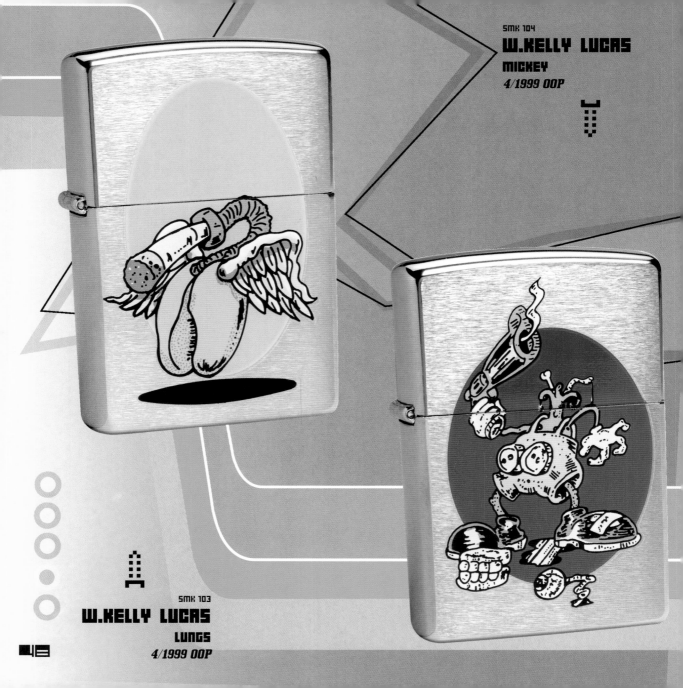

SMK 103
W.KELLY LUCAS
LUNGS
4/1999 OOP

48

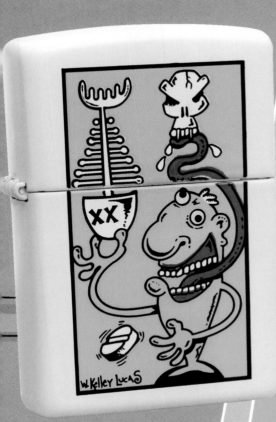

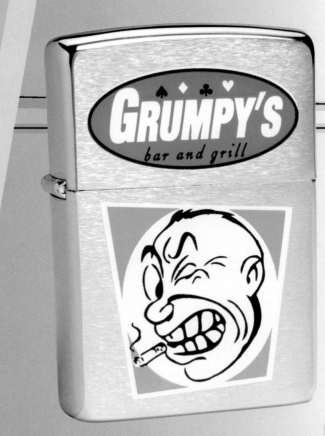

SMK 105
W.KELLY LUCAS
LICK
4/1999 OOP

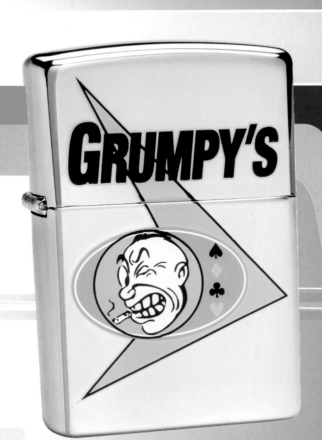

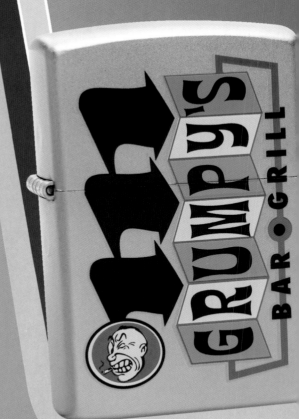

SMK 62
GRUMPYS BAR
ARROW
11/1997

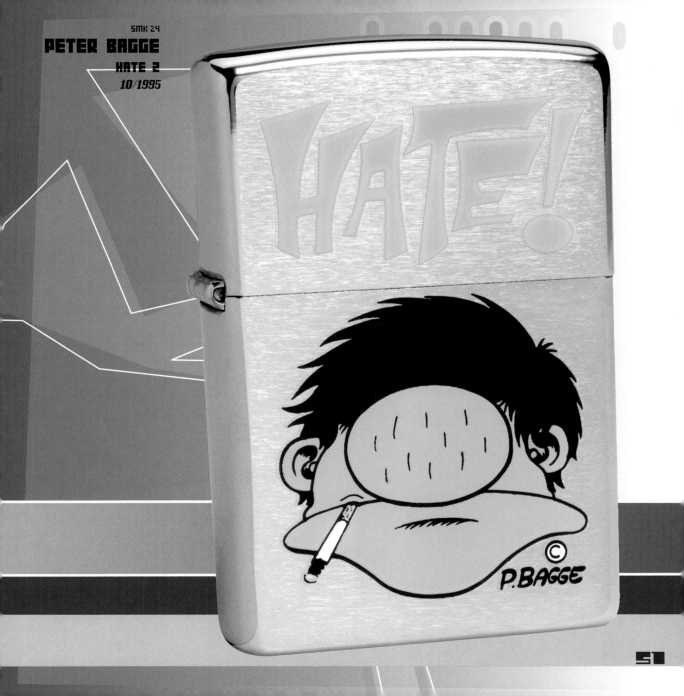

HATE!

P.BAGGE ©

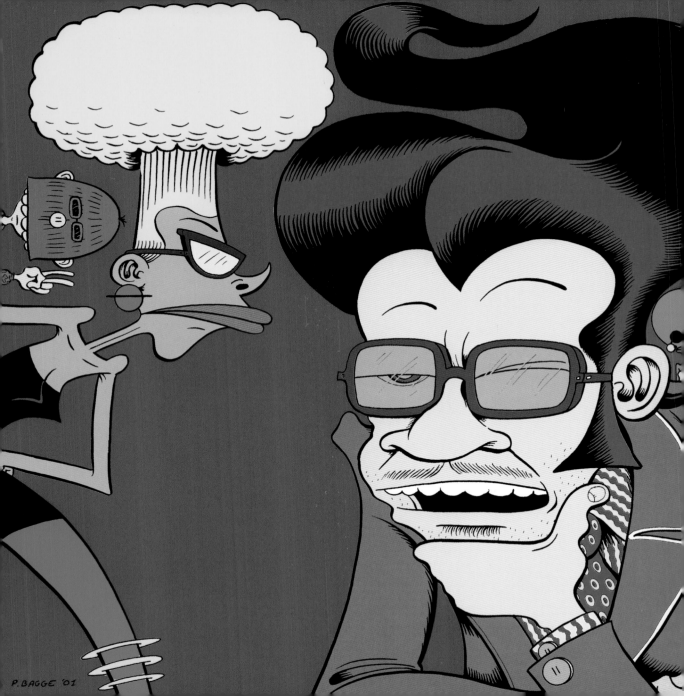

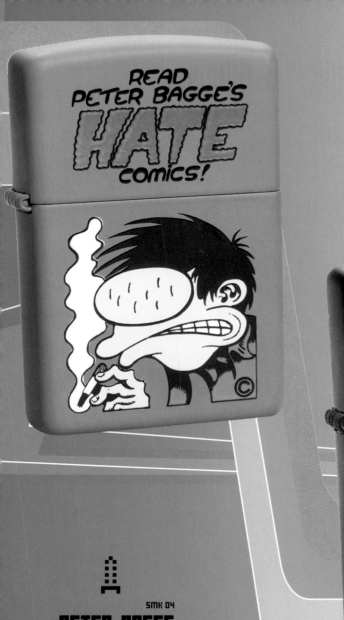

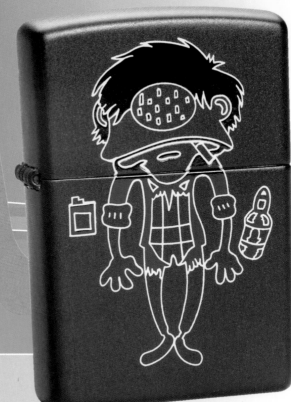

SMK 04

PETER BAGGE

HATE

11/1994 OOP

TER BAGGE SOME DUMB DRAWING

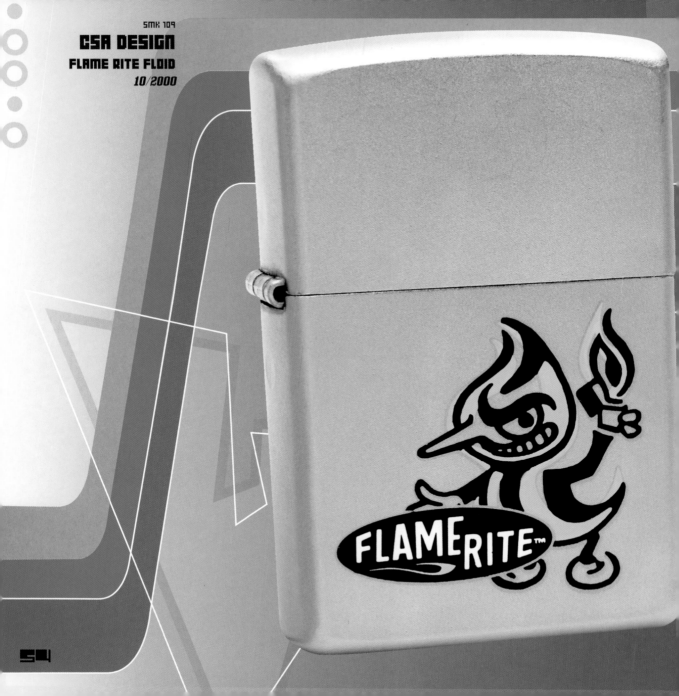

FLAME RITE™

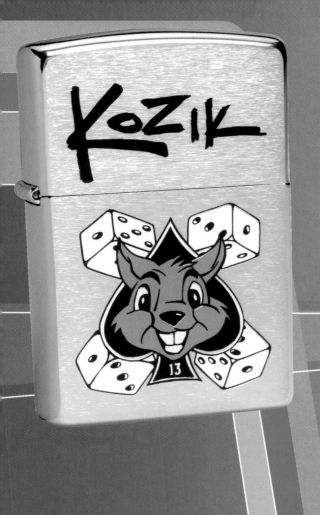

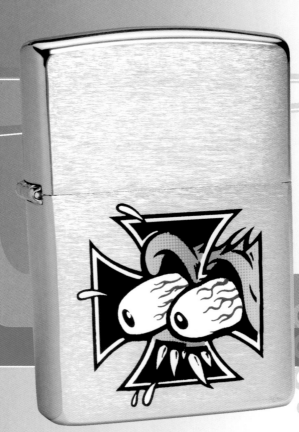

SMK 03

FRANK KOZIK

SQUIRREL

11/1994 OOP

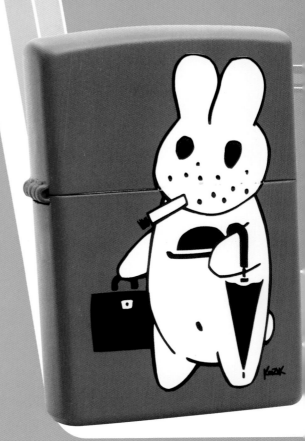

SMK 68
FRANK KOZIK
DOGGY
11/1998 OOP

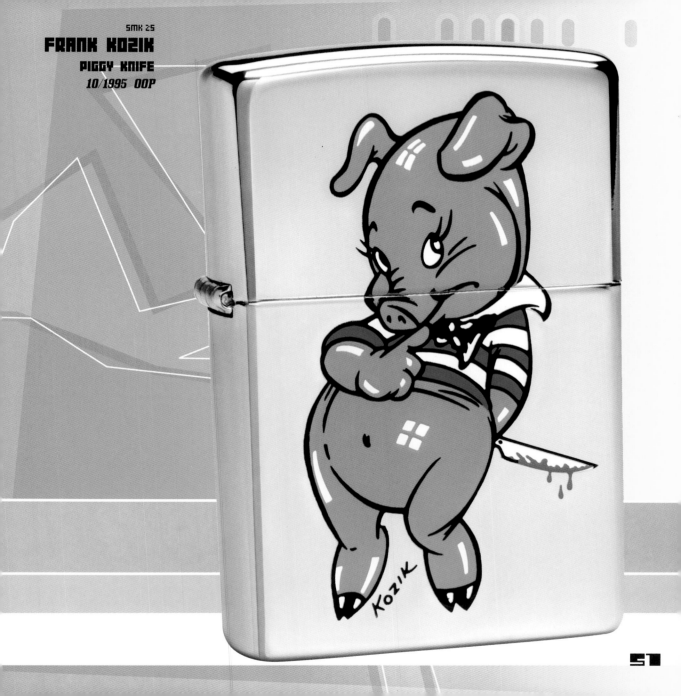

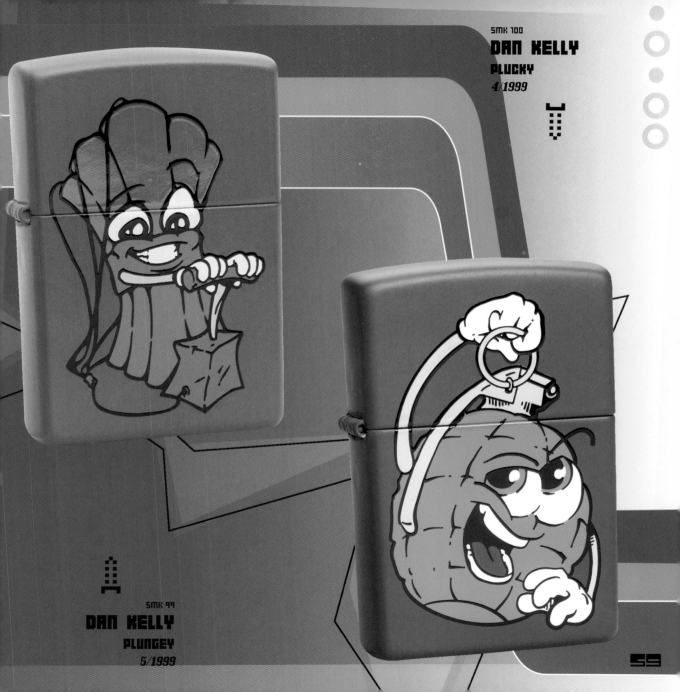

59

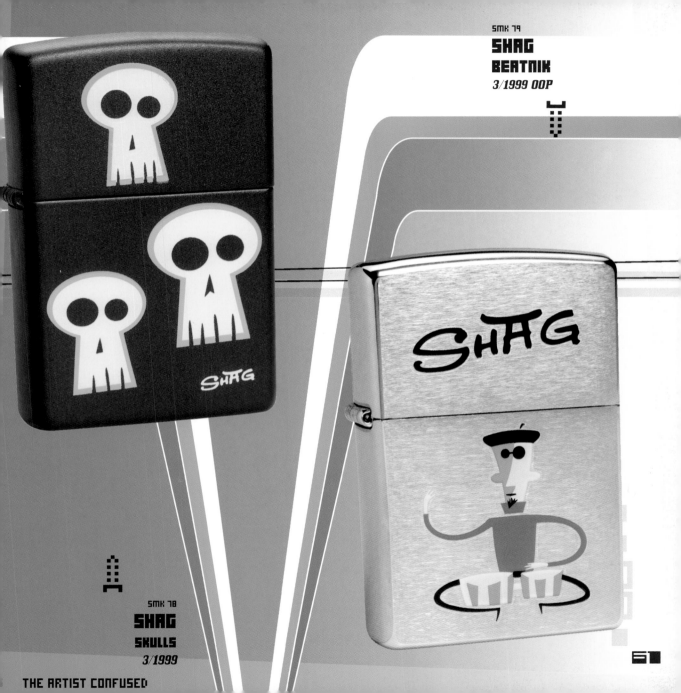

SMK 79
SHAG
BEATNIK
3/1999 OOP

SMK 78
SHAG
SKULLS
3/1999

THE ARTIST CONFUSED

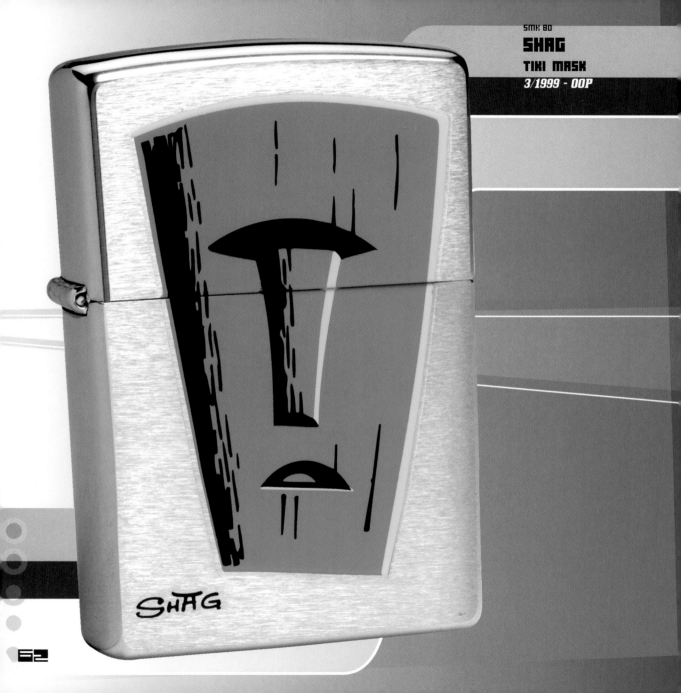

SHAG

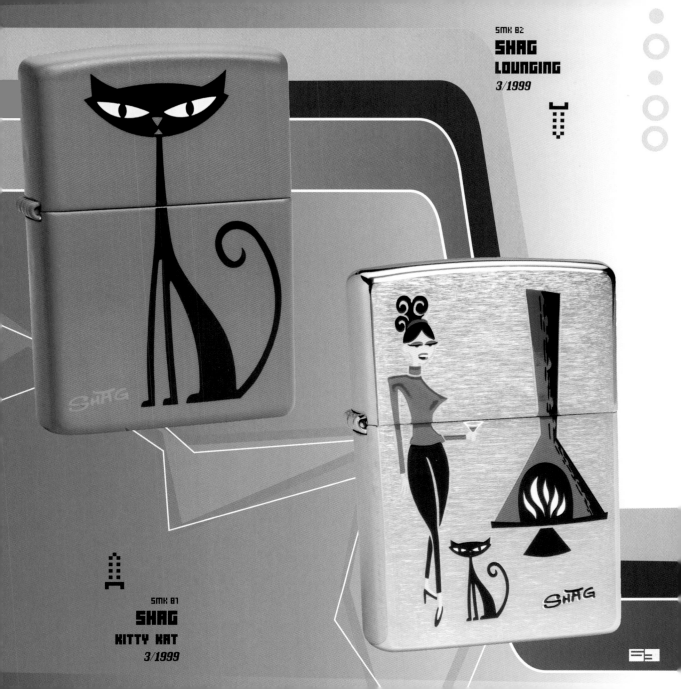

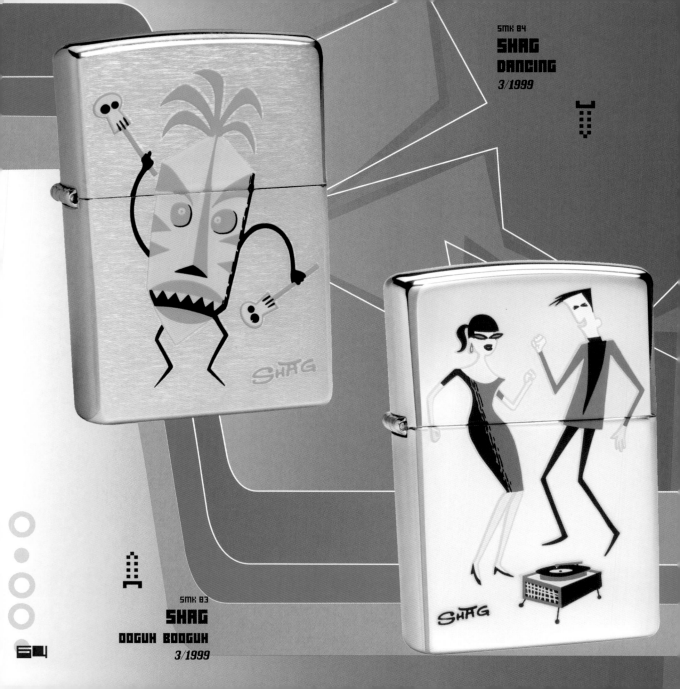

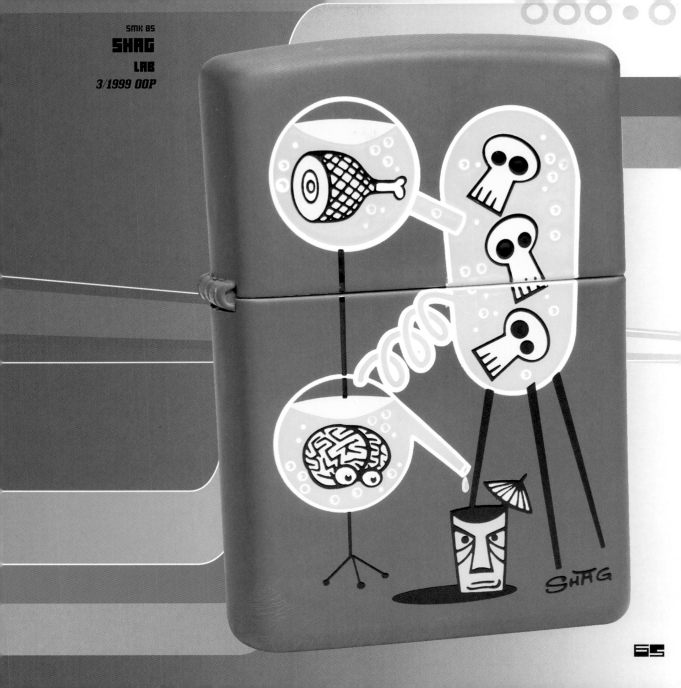

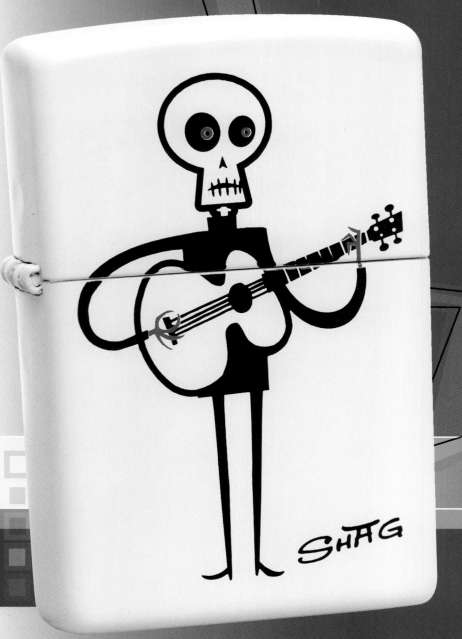

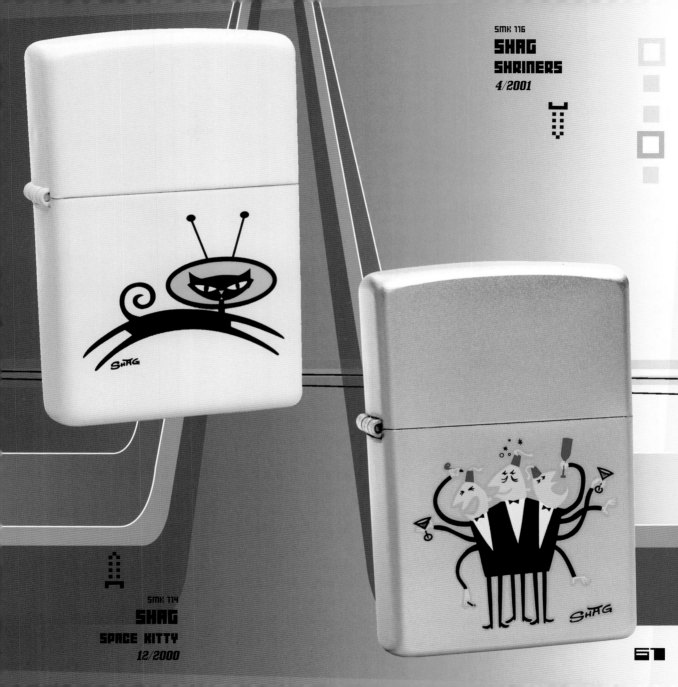

SMK 114
SHAG
SPACE KITTY
12/2000

67

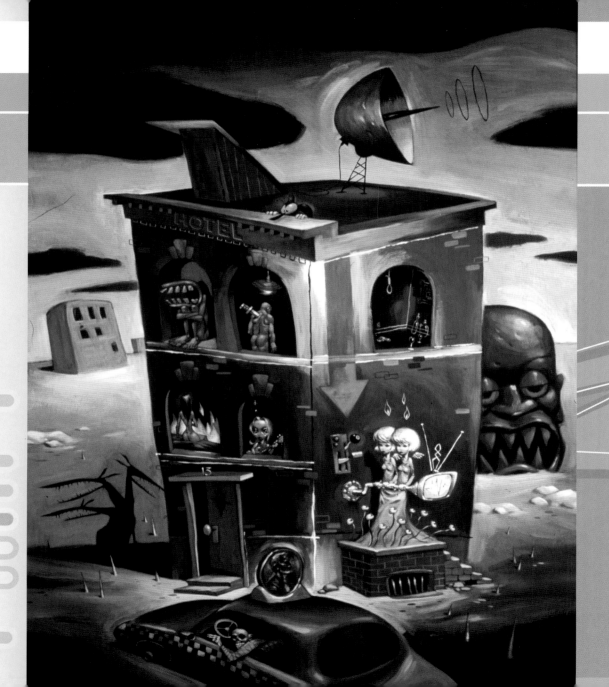

GLENN BARR DESCENSION HOTEL ACRYLIC ON MASONITE 36X48

SMK 44
GLENN BARR
GAA
6/1996

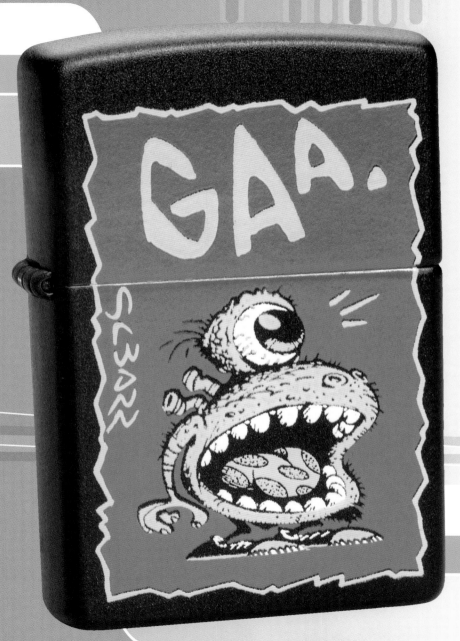

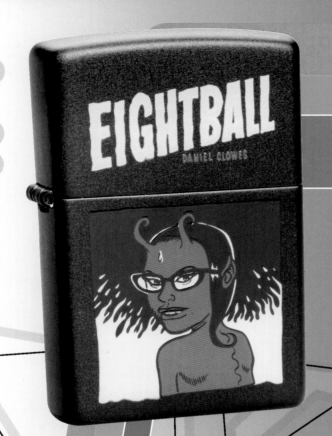

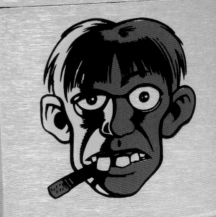

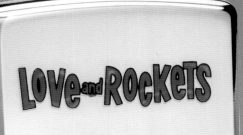

BETO HERNANDEZ
LOVE & ROCKETS 2
6/1996 OOP

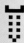

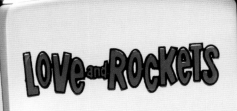

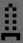

SMK 26

XAIME HERNANDEZ
LOVE & ROCKETS 1
11/1995

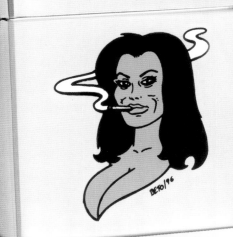

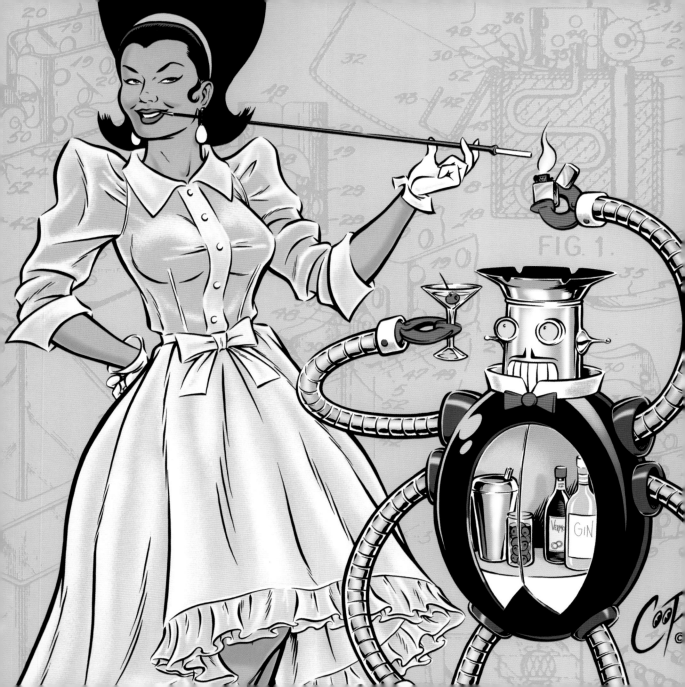

FIG. 1.

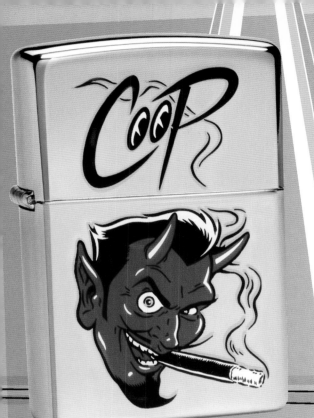

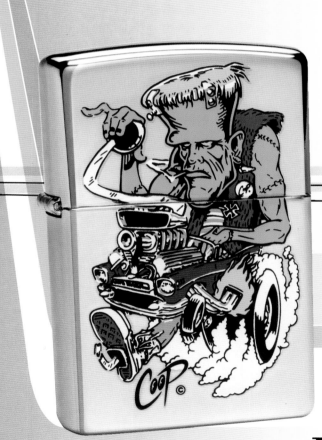

SMK 02
COOP
DEVIL HEAD
10/1994

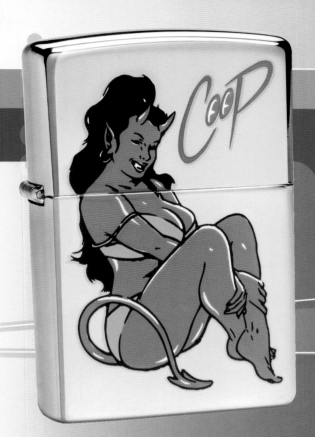

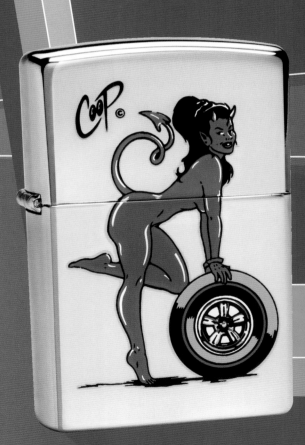

SMK 36
**COOP
DEVIL GIRL**
9/1996

74

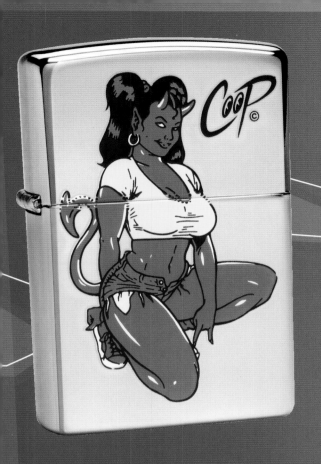

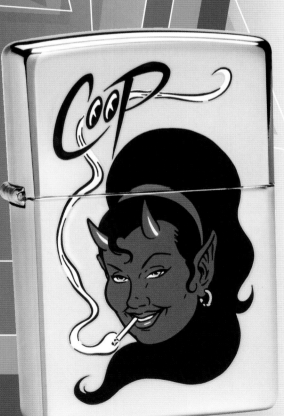

SMK 77
COOP
POP GIRL
3/1999 OOP

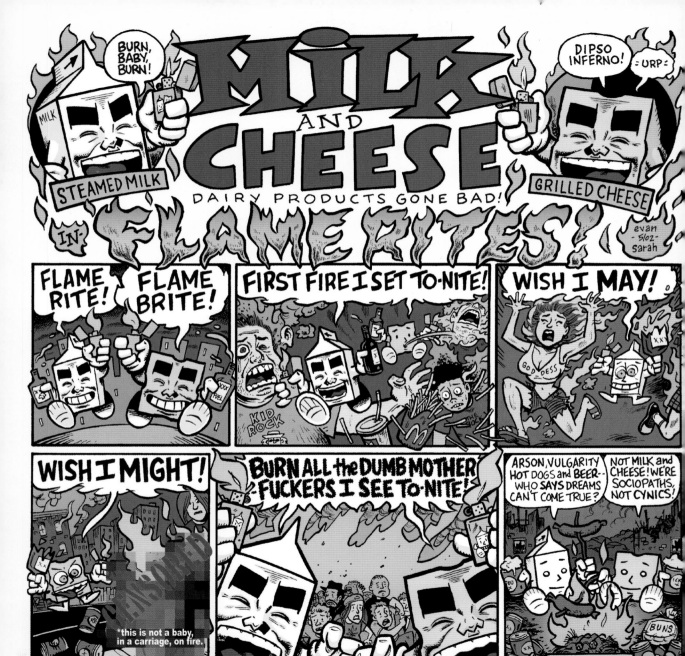

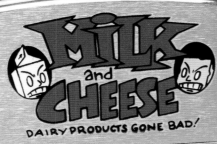

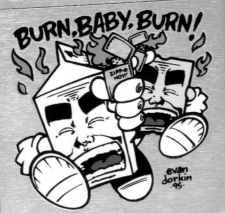

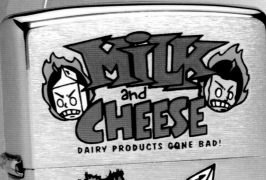

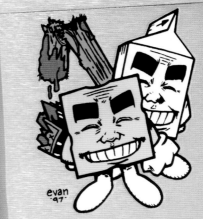

SMK 23

EVAN DORKIN
MILK & CHEES
10/1995

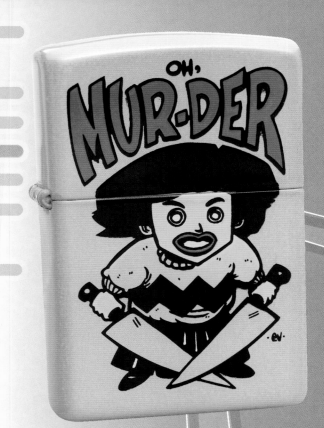

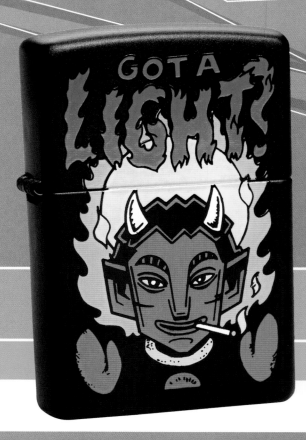

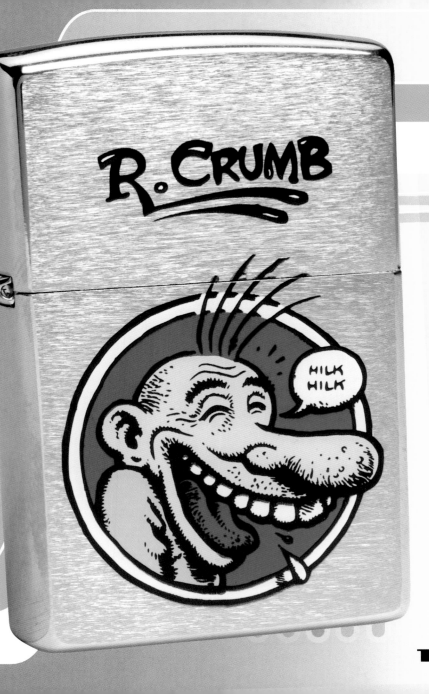

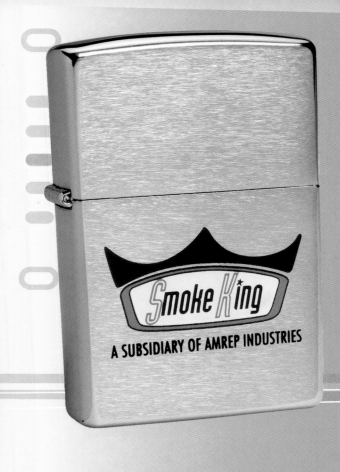

SMK 06

HAZE XXL
ORIG CORP LOGO
11/1994 OOP

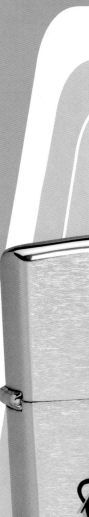

SMK 20

HAZE XXL
ATOMIC
4/1995 OOP

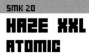

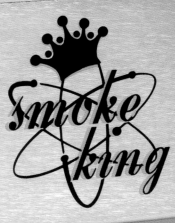

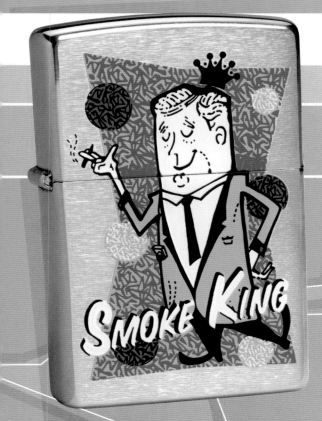

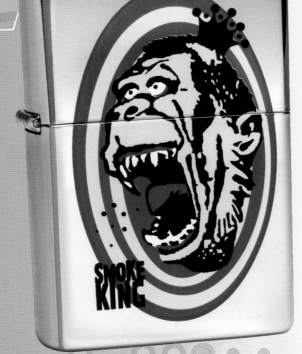

SMK 33
HAZE XXL
MR. SUAVE
6/1996 OOP

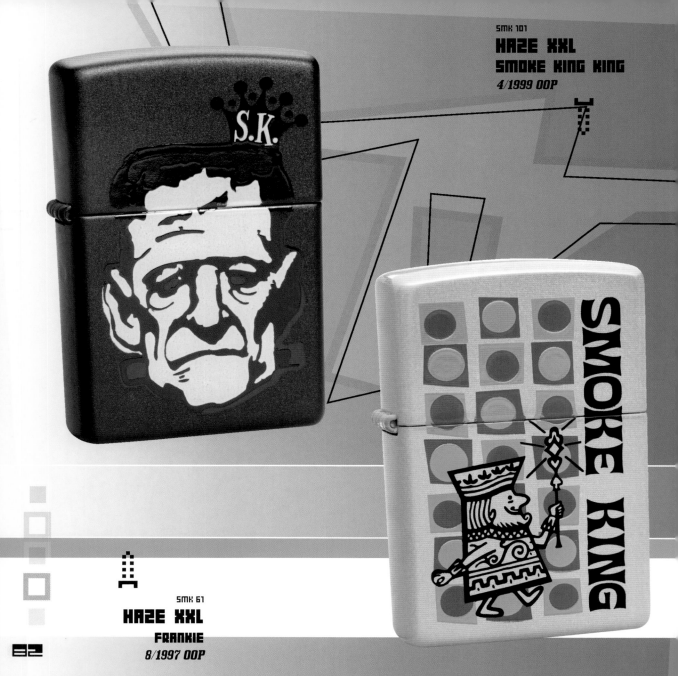

SMK 61
HAZE XXL
FRANKIE
8/1997 OOP

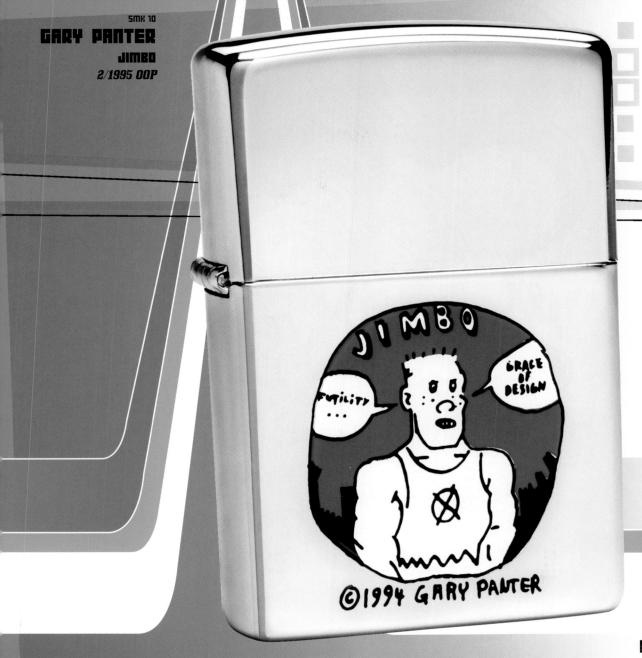

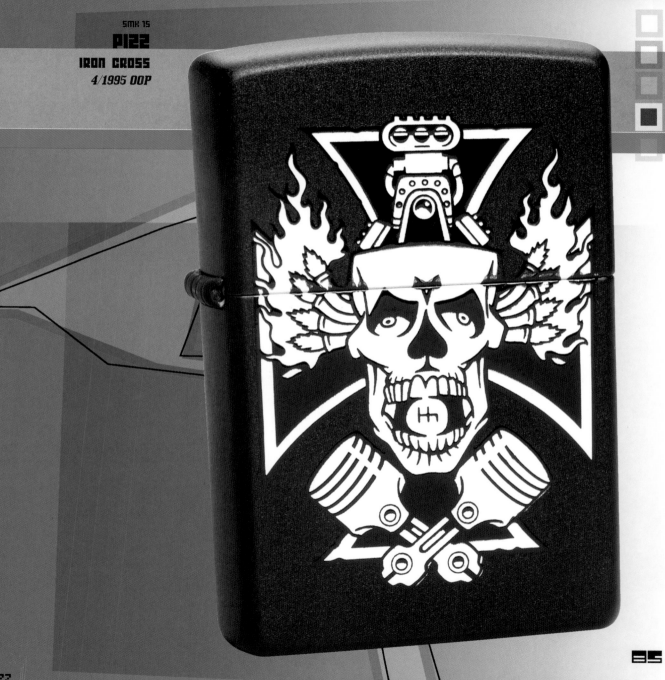

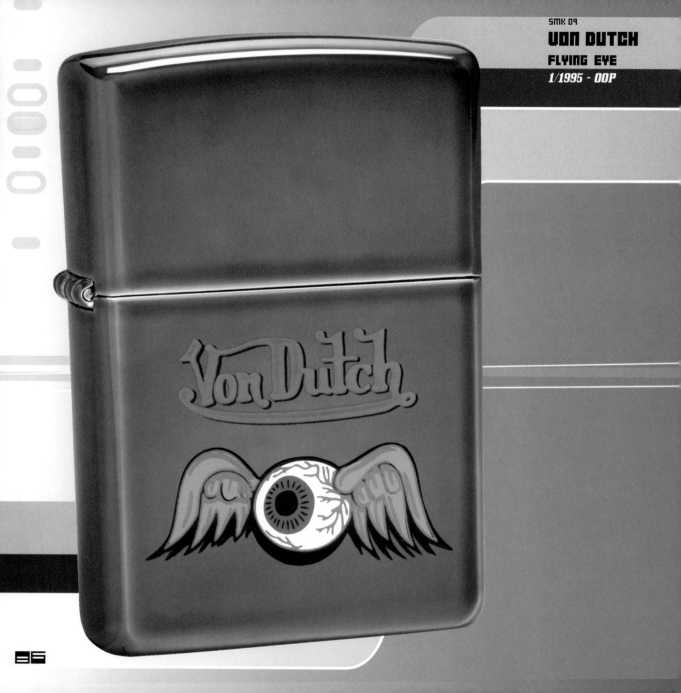

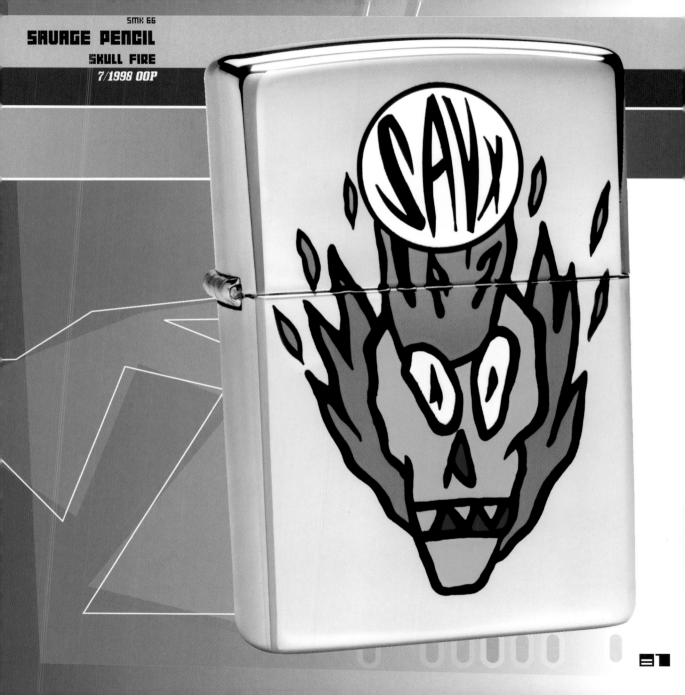

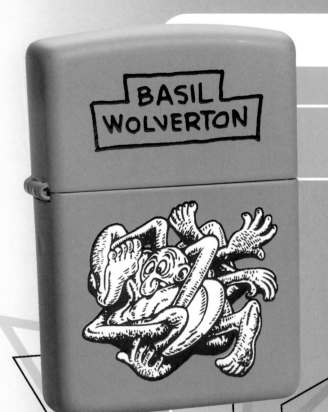

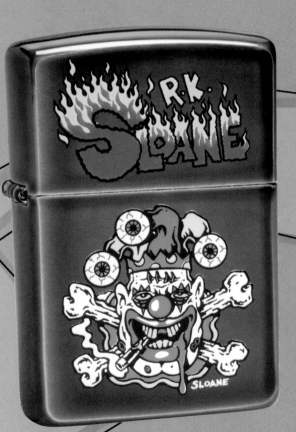

SMK 08
BASIL WOLVERTON
KNOT MAN
1/1995 - OOP

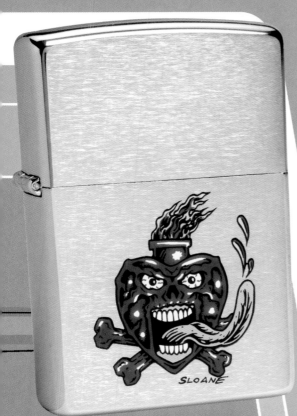

R.K. SLOANE
DEVIL FETUS
4/1999

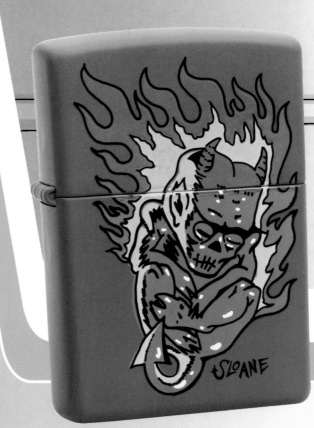

SMK 50
R.K. SLOANE
HART BERN
10/1997 - OOP

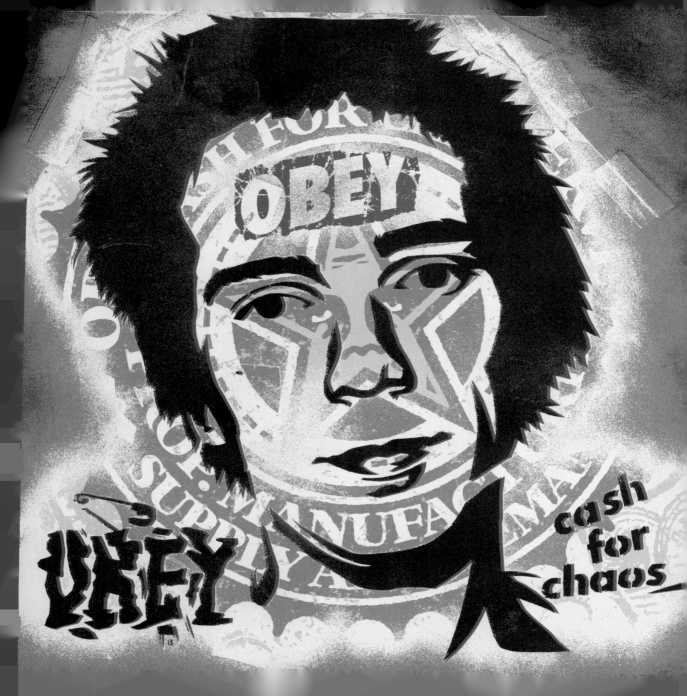

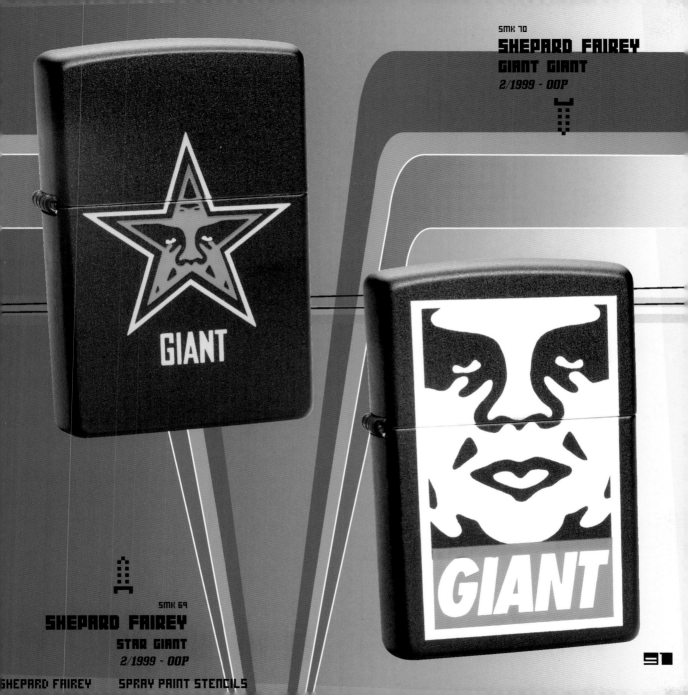

GIANT

GIANT

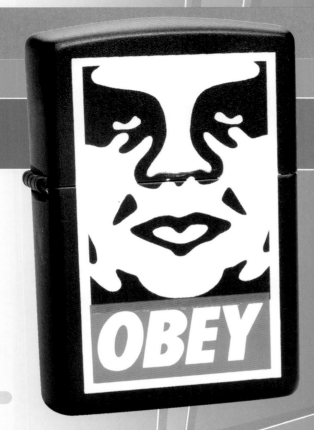

SHEPARD FAIREY
DEVIL GIANT
2/1999 OOP

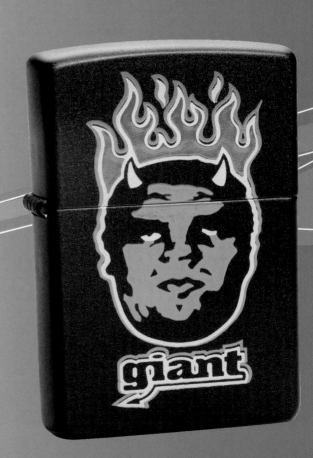

SMK 71
SHEPARD FAIREY
OBEY GIANT
2/1999

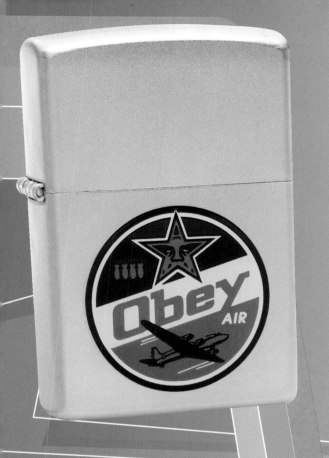

SMK 111

SHEPARD FAIREY

OBEY AIR

2/2001

93

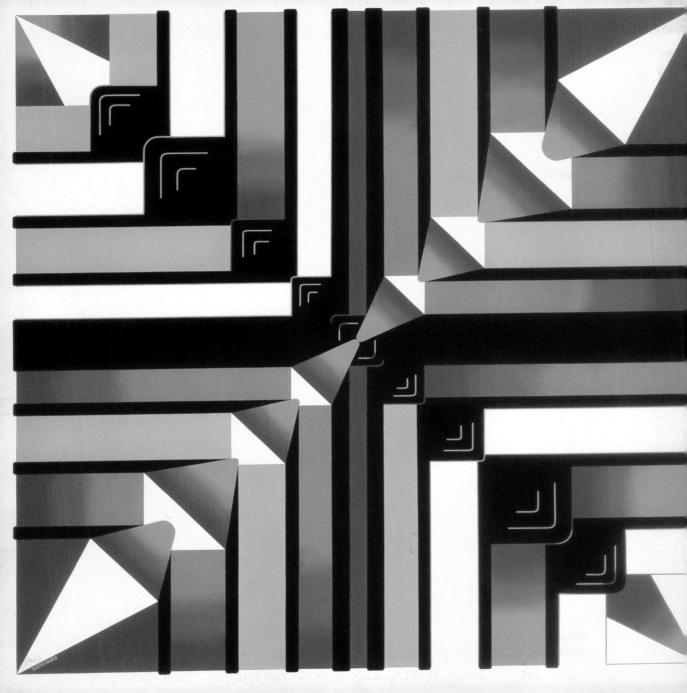

SUZANNE WILLIAMS EXERCISE IN PERPENDICULAR RESULTING IN SECONDARY DIAGONAL OIL ON CANVAS 29"X29"

CONTRIBUTING ARTISTS

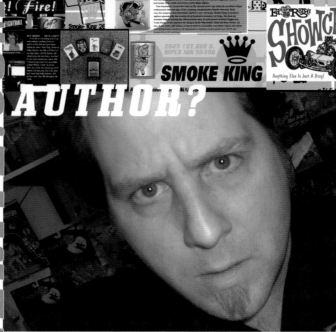

AUTHOR?

 Tom Hazelmyer is the owner/curator of Grumpy's City Club Gallery in Minneapolis, possibly the first working man's bar/art gallery (how's that for Low Brow?). His design credentials include hundreds of projects and products from record sleeves and rock posters down to T-shirts and matchbooks. Hazelmyer spent the early 80's as both a Hardcore youth and as a Marine (the other hard Corps.). During this period he formed the infamous post-Hardcore/pre-Grunge band Halo Of Flies, and also served time in Killdozer and Seattle's U-Men. Not coincidentally, he started and ran Amphetamine Reptile Records (or AMREP, as it was affectionately monikered), the most notorious 90's indie record label. In addition, he also founded Flame Rite, a separate company created to bring a dose of underground art to the All-American Zippo. Currently he can be found eating fried foods, downing aquavit by the gallon, and screaming "keep your freaking hands off the art" at his three children.

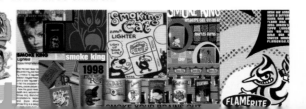

www.FLAMERITE.COM